STUBBS : PORTRAITS IN DETAIL

STUBBS
Portraits in Detail

SELECTED AND INTRODUCED BY
JUDY EGERTON

THE TATE GALLERY

cover
**Gimcrack on Newmarket Heath, with a Trainer,
Jockey and Stable-Lad** *circa* 1765 (detail)

ISBN 0 946590 17 6
Published by order of the Trustees 1984
for the exhibition 18 October 1984–6 January 1985
Copyright © 1984 The Tate Gallery
Published by Tate Gallery Publications,
Millbank, London SW1P 4RG Designed by Caroline Johnston
Printed in Great Britain by Balding + Mansell Limited, Wisbech, Cambs

Tate Gallery Publications gratefully acknowledge the
support of Britoil in the publication of this book

CONTENTS

INTRODUCTION

'Every Object in this Picture was a Portrait', wrote Mary Spencer, Stubbs's life-long companion, about his painting 'The Grosvenor Hunt'. Her remark fits almost every picture Stubbs painted. Applied, for instance, to the first subject in this book – 'The 3rd Duchess of Richmond and Lady Louisa Lennox watching the Duke's Racehorses at Exercise' – the phrase emphasizes the fact that not only each lady but also each servant, from the head groom to the smallest stable-lad, is portrayed as an individual, that the racehorses are particular animals from the Duke's stables and that the five little dogs are insistently individual pets of the household or stable-yard. Even the distant landscape is a 'portrait' of the view from Goodwood Park looking over Chichester to the Solent and, beyond it, to the gently swelling line of the Isle of Wight.

Stubbs made his name as the portraitist of horses. His paintings of horses were directly founded on anatomical study, undertaken during eighteen months of dissection and intent draughtsmanship. This interest in anatomy lasted all his life, and the anatomical drawings made in his seventies show no lessening of his powers of observation. But Stubbs should not be thought of as a scientist *manqué*. He was an artist first and foremost: *George Stubbs, Painter* was how he styled himself on the title-page of *The Anatomy of the Horse*, and how he wished to be regarded.

Stubbs as a painter of human beings was a most perceptive portraitist, and as much a master of the art of class distinction in eighteenth-century England as he was of animal anatomy. The features of his upper- and middle-class sitters may not differ in essentials from those of his grooms, jockeys, stable-lads and farm-labourers; it is their deportment which is different. Sitters like those in 'The Milbanke and Melbourne Families' are portrayed as conscious of their position in the world, and assured of their right to enjoy their leisure. Stubbs's haymakers and reapers, like his grooms and jockeys, are in a

different class. Their assurance derives from their ability to do a job well and to see it through. Their actions are skilled, intent and unselfconscious; but their faces, once seen in Stubbs's portraits, stay in the mind.

Stubbs is not a narrative artist, painting to relate a story or depict an event; nor does he seek to point a moral or embody an allegory. His subjects are drawn from life. He paints people, animals, places and things as truthfully as he can, and, if he can do so without flattery or falsehood, as gracefully as he can. Stubbs has the gift of making unforgettable images out of quite commonplace ingredients: it is the affection with which he regards them that makes them memorable. The very weeds in his foregrounds are individually and lovingly portrayed.

Above all, Stubbs is a master of design. All his compositions are worked out very carefully, so that each detail plays its part, and every object is related, often with hair's-breadth judgment, to the space around it. This mastery of design is illustrated here by the way in which Stubbs constructed his picture of the 'Haymakers' of 1785, and in the very different way in which he superimposed, upon a study of the Newmarket landscape painted some thirty-five years earlier, the monumental image of the racehorse 'Hambletonian' and his attendants.

All the paintings in this book, with the exception of 'Gimcrack on Newmarket Heath with a Jockey, Trainer and Stable-Lad', have been deliberately chosen from collections which are open to the public in England, Northern Ireland and America. Our details are not intended to prefer the beauty of parts to the beauty of the whole picture, but rather to show the way in which Stubbs designs a picture and the qualities with which he infuses it. Details, however exquisitely painted, do not by themselves add up to great works of art, but they may sometimes illuminate ways in which a great artist gets to the heart of things.

The Duchess of Richmond and Lady Louisa Lennox watching the Duke's Racehorses at Exercise

? painted in 1760
Oil on canvas, 50¼ × 80¾ in. (127.6 × 205.6 cm.)
Trustees of the Goodwood Collection, Goodwood House, Chichester

This is one of three canvases commissioned from Stubbs by the 3rd Duke of Richmond to show different members of his family and circle of friends hunting, shooting and watching racehorses at exercise; all three are still at the Duke's seat, Goodwood House.

This picture almost divides itself into three groups, with no loss of cohesion. The central group is led by the young Duchess of Richmond and her sister-in-law Lady Louisa Lennox; both are wearing the Goodwood blue, the livery of the Charlton Hunt. The Duchesss of Richmond would have been twenty-six years old in 1760; Stubbs's portrait of her is very like the portrait painted a few years later by Reynolds (at Goodwood House). The Duke himself appears only in the Goodwood 'Hunting' picture, probably because at this stage of his career he was often abroad on military service. The ladies are escorted here by a dark-complexioned man who may be Richard Buckner, the Goodwood steward, and an important man in his own right.

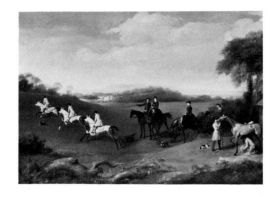

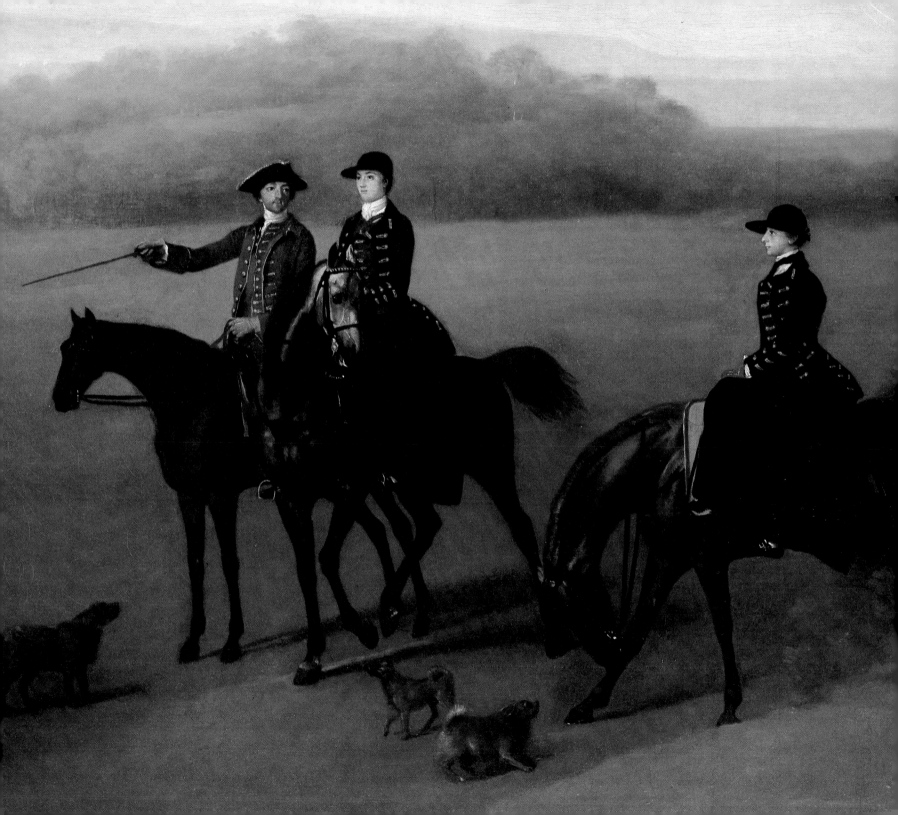

The Duchess of Richmond and Lady Louisa Lennox watching the Duke's Racehorses at Exercise

DETAIL II

The Duke of Richmond's racehorses at exercise wear hooded sweat-covers in the Goodwood household livery: yellow bordered with red. There is something almost surreal about the measured pace at which they proceed, each progressively foreshortened as they move as if to canter off the canvas. Their decorous rhythm seems to tell us something about this ducal household – that this is a well-ordered establishment, in which everything runs smoothly and apparently effortlessly – as well as about the time-honoured method of exercising racehorses in heavy covers to make them sweat freely.

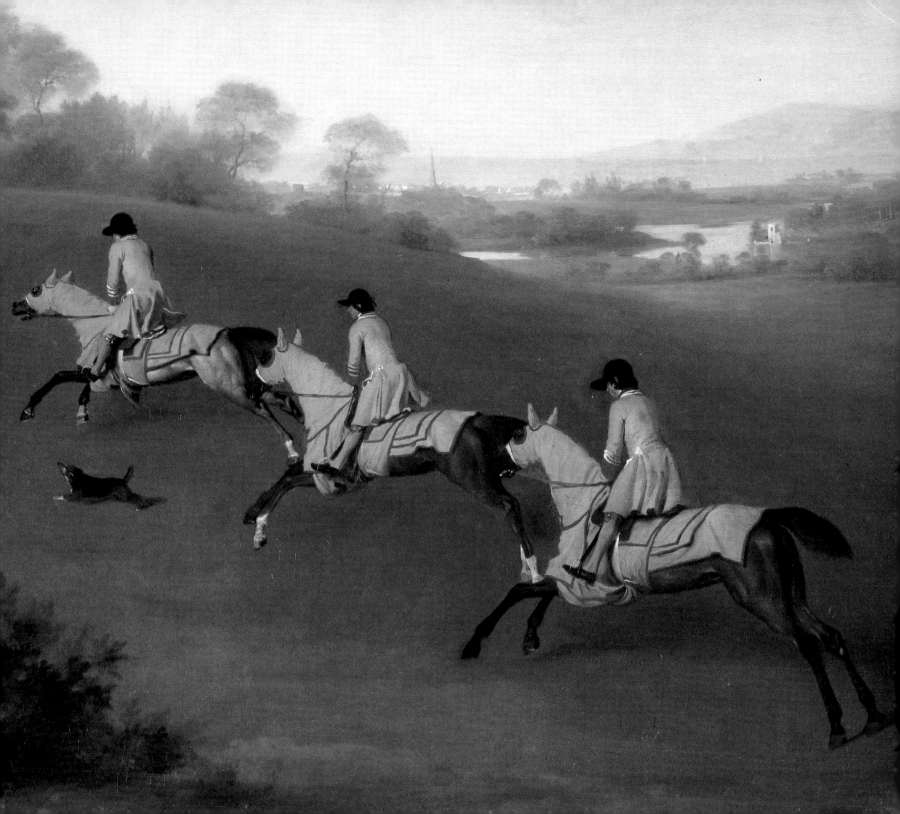

The Duchess of Richmond and Lady Louisa Lennox watching the Duke's Racehorses at Exercise

DETAIL III

This group shows a racehorse being rubbed down after exercise. The relationship between the groom at the horse's head and the horse itself seems to epitomize the sympathetic yet enormously capable manner in which Stubbs's grooms, jockeys and stable-lads look after the animals in their care; the sotto voce murmurs with which this groom reassures the tired animal are almost audible. A stable-lad gathers fresh straw for the head groom to use as a wisp; an even younger lad staggers in with more straw. The Goodwood servants are as much drawn from life as their masters are. Although there is a contemporary Register of the Servants at Goodwood, not many of them are easily identifiable. Here the head groom is probably William Budd, whose nephew Christopher Budd junior was a stable-lad. Many of the servants came from the neighbouring village of Charlton.

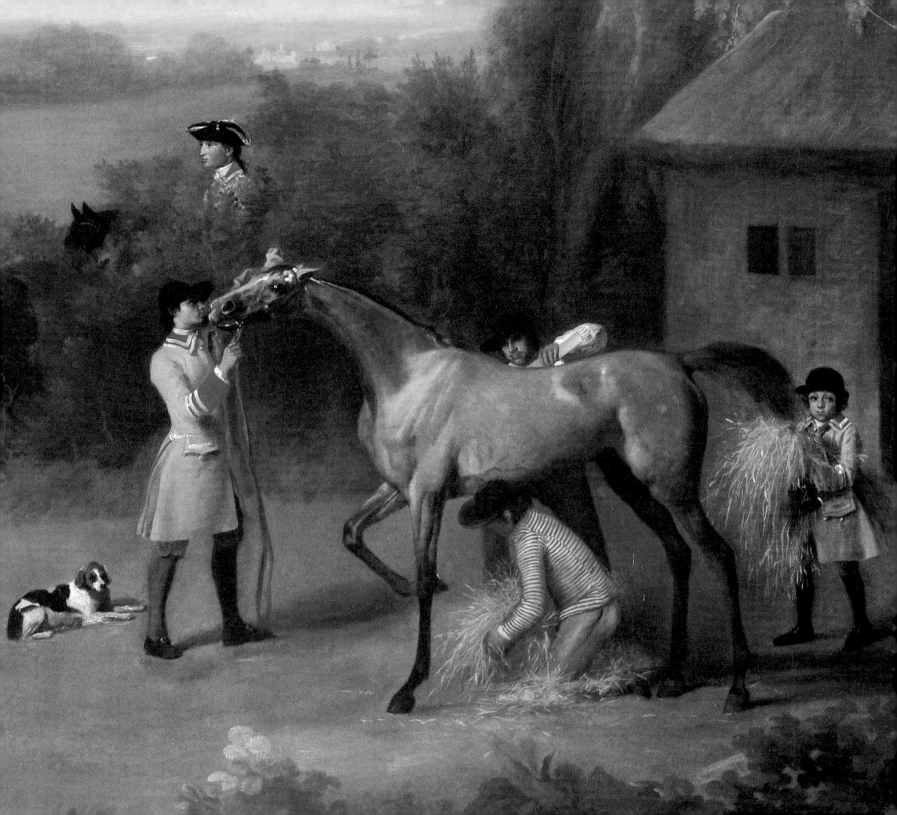

MOLLY LONG-LEGS

exhibited 1762

Oil on canvas, $39\frac{3}{4} \times 49\frac{7}{8}$ in. (100 × 126.8 cm.)

Merseyside County Council, Walker Art Gallery, Liverpool

Stubbs's pictures of racehorses and jockeys give equal weight to the portraiture of the individual horse and the individual person who rides it. He had devoted eighteen arduous months earlier in his career to studying the anatomy of the horse, dissecting horses and making detailed drawings of every stage of dissection from the outer skin to the skeleton; later he engraved his drawings and published them, with a text, as *The Anatomy of the Horse*. The knowledge Stubbs acquired during this intensive first-hand study informs every portrait of a racehorse or hunter which he undertook. His eye for character makes every portrait of a human being, whether a duke or a jockey, highly individual. The identity of this jockey is no longer known (contemporary racing calendars did not record jockeys' names), but there can be no doubt that here is the portrait of a particular individual: sturdy, shrewd and entirely in sympathy with his mount.

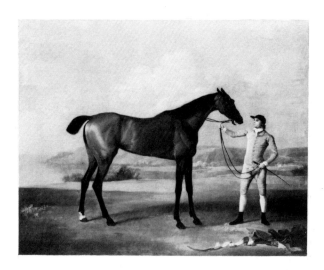

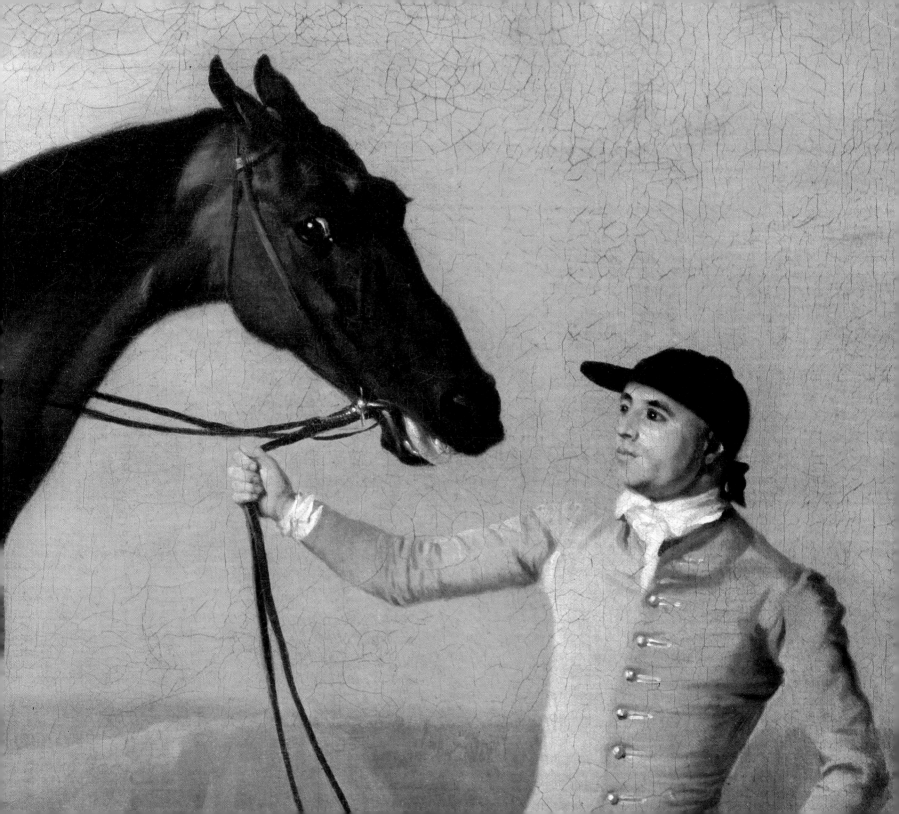

Gimcrack on Newmarket Heath, with a Trainer, Jockey and Stable-Lad

circa 1765
Oil on canvas, 40 × 76 in. (101.6 × 193.2 cm.)
Private Collection

Gimcrack was one of the most famous racehorses of eighteenth-century England, and probably the most popular of them all, seeming to possess a gallantness which endeared him to the public as well as a turn of speed which made him a valuable property. He was unusually small – just over fourteen hands – yet he raced for over eleven years, surviving many changes of ownership, including positive maltreatment in France. His most celebrated victory was in a match for 1,000 guineas against Ascham on 10 July 1765: Lady Sarah Bunbury wrote that she had been at Newmarket that day 'to see the sweetest little horse run that ever was; his name is Gimcrack, he is delightful'. It was that victory which his then owner, Lord Bolingbroke, asked Stubbs to commemorate.

As always with Stubbs, there is no crowd: the victory is almost a private affair between the horse, his jockey, his trainer and the stable-lad who lifts his gaze in respectful wonder. The trainer at the horse's head holds the reins in a beautifully judged pose which is at once natural and celebratory.

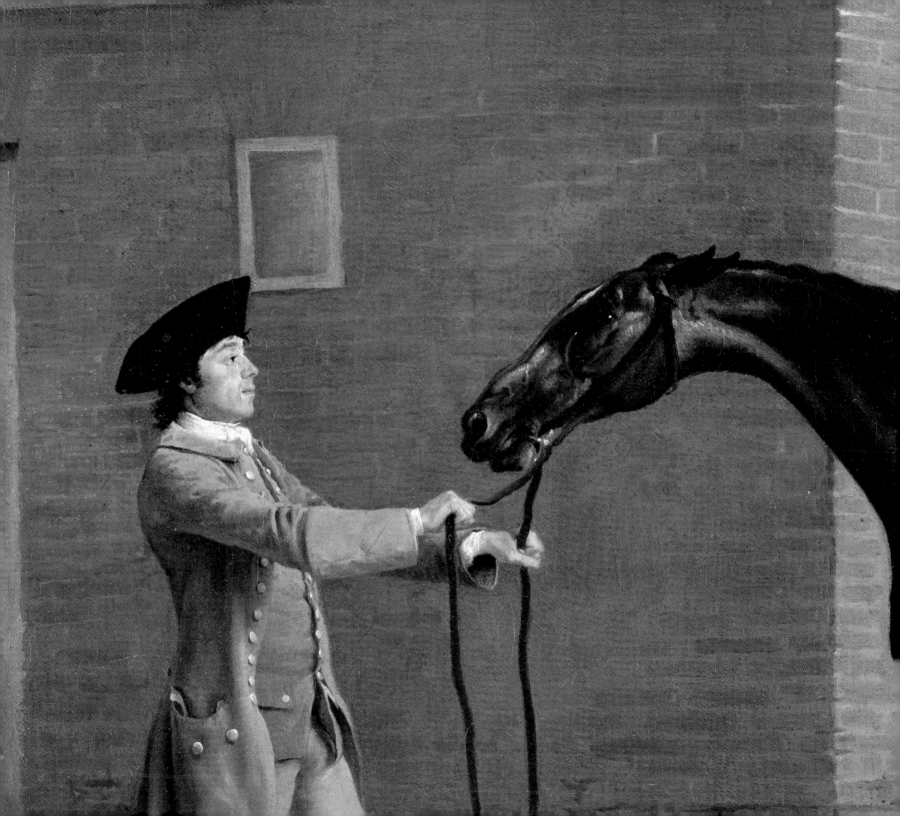

Cheetah and Stag with Two Indians

exhibited 1765

Oil on canvas, $71\frac{1}{8} \times 107\frac{5}{8}$ in. (180.7 × 273.3 cm.)

City of Manchester Art Galleries

The cheetah, probably the first ever seen in England, was a present to King George III from Sir George Pigot, Governor-General of Madras. The King gave it into the care of his brother, the Duke of Cumberland, who kept a menagerie in Windsor Great Park. Wishing to discover how cheetahs attacked their prey, the Duke staged an experiment; one of the Windsor Forest stags was placed within a netted enclosure, inside which the cheetah was let loose. Though the stag came best out of this encounter, repeatedly driving the cheetah off with its antlers, spectators were able to observe that the cheetah attacked 'like a cat creeping slowly on the ground till within reach of its prey, and then, by a spring, leaping on it'.

Wisely, Pigot had arranged for two Indians, experts in training the cheetah for the chase, to accompany the animal to England. Stubbs portrays the Indians with the same observant and unprejudiced eye which he brought to all his subjects; his Indians have been judged the finest rendering of Indians in British painting. Stubbs paints their billowing white robes with meticulous observation, rendering each fold as if he were painting a still-life, and with as much care as if the thin muslin stuff were cloth of gold.

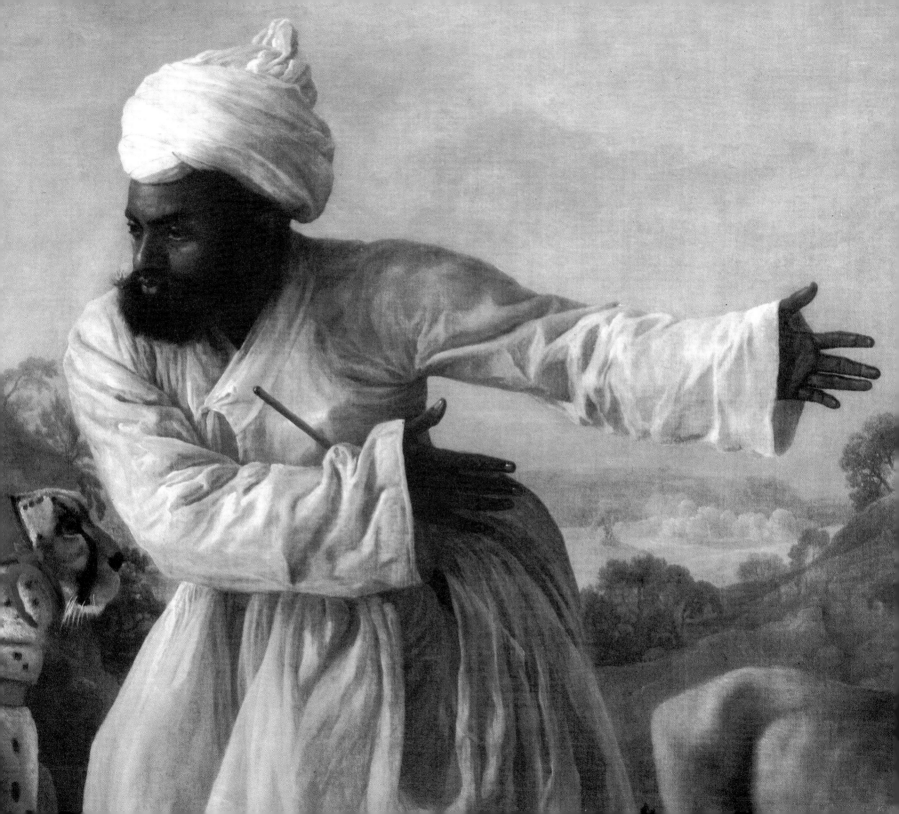

CHEETAH AND STAG WITH TWO INDIANS

DETAIL II

The realism and accuracy with which Stubbs painted animals have no precedent in art, and have never been surpassed. Stubbs's realism is the product of intent observation coupled with keen interest in all animal species. He wishes to portray the cheetah, just as he wished to portray the zebra, the monkey or the rhinoceros, by a comprehensive summing-up of its form and its instincts, preferring to try to capture its essential character rather than to depict any particular incident in its behaviour. The cheetah wears the scarlet accoutrements of a creature trained for princely sport; though it stands for the moment quietly, we have no difficulty in sensing the swiftness and grace with which this lithe and beautiful creature, once released, will pursue and finally spring upon its prey.

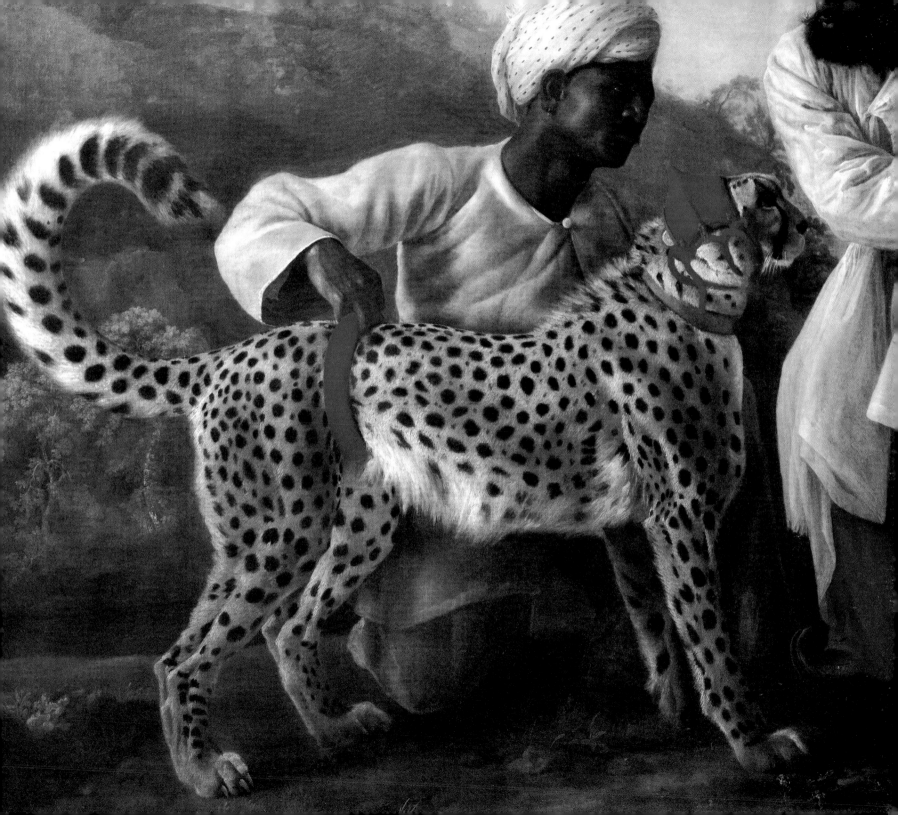

The Duke of Dorset's Hunter with a Groom

dated 1768

Oil on canvas, 40 × 49¾ in. (101.6 × 126.4 cm.)

Metropolitan Museum of Art, New York, Bequest of Mrs Paul Moore 1980

This painting, little-known in England before the Tate Gallery's *Stubbs* exhibition of 1984–5, belongs to Stubbs's prime period, the decade of the 1760s, when his genius blossomed freely and variously, whether he was painting exotic animals, conversation pieces or portraits of horses with their attendants. Here horse and groom seem to understand each other perfectly, as they wait quietly for a groom to usher in the master and bring his saddle. The dog wears a gold collar, and is evidently a ducal pet as well as a faithful companion in the stables.

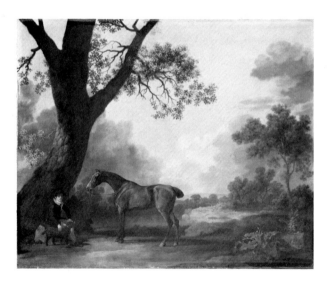

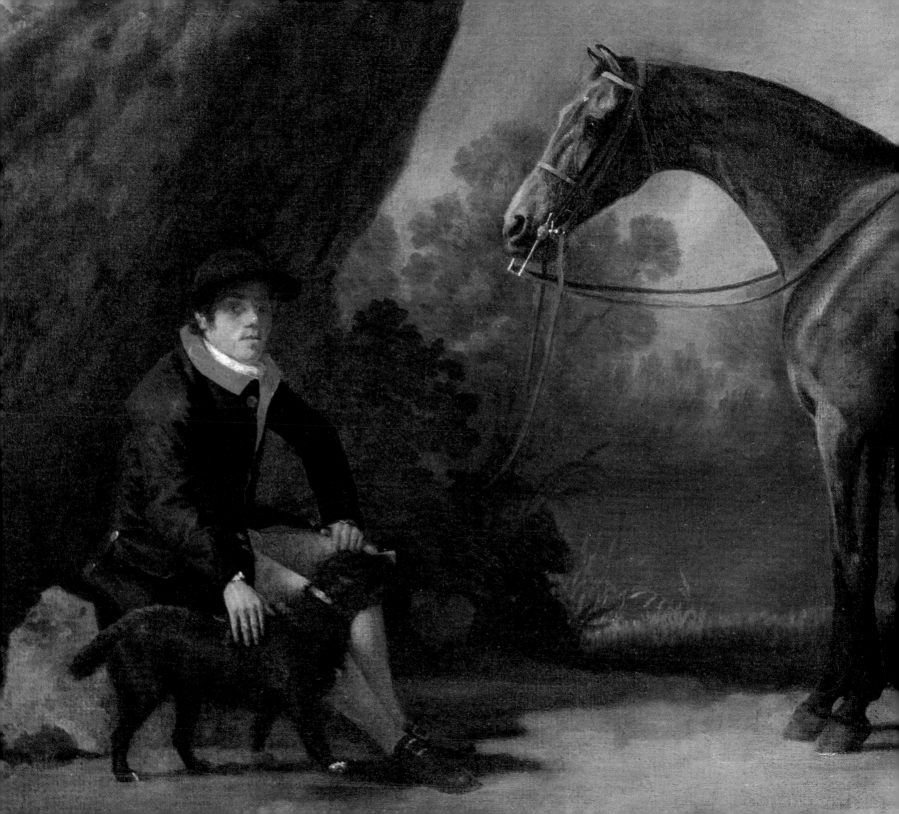

The Duke of Dorset's Hunter with a Groom

DETAIL II

In the 1760s Stubbs's confidence in himself as a landscape painter as well as a horse painter was at its highest. In many works of this period, the landscape is drawn from nature, and the result is as fresh and as finely rendered as in Gainsborough's early work. Stubbs draws his trees and wild plants, including weeds, in loving detail, and from life. Here is a group of wild plants, *arum maculatum* ('Lords and Ladies') and *umbilicus rupestris* ('navelwort'), with flowering grasses growing through them. Sometimes the plants he introduces echo a horse's name, as in his portraits of 'Sweet William' and 'Sweet Briar': can the plants depicted here offer some clue to this hunter's name?

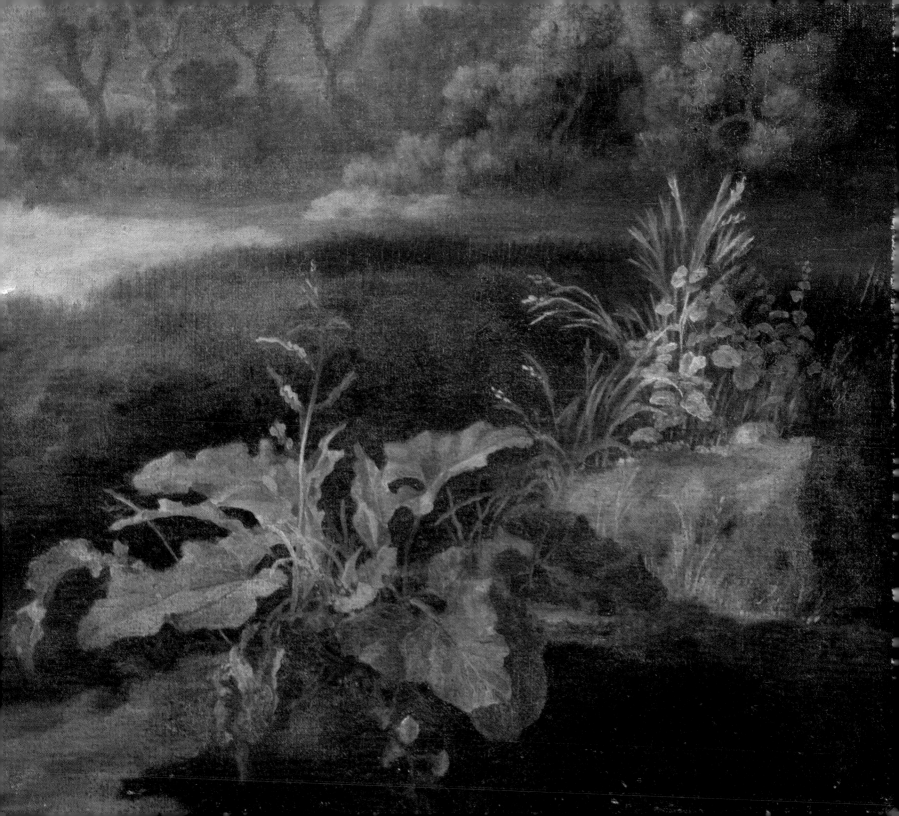

A Repose after Shooting

dated 1770

Oil on canvas, 39 × 49 in. (99 × 124.5 cm.)

Yale Center for British Art, Paul Mellon Collection, given in memory of his friend
James Cox Brady, Yale College, Class of 1929

This is the last of a series of four paintings which depict two friends spending a day shooting in and around Creswell Crags, on the Nottinghamshire-Derbyshire border. The two men are clearly individuals, portrayed from life, though their identity is now unknown; they are evidently unpretentious men who enjoy a day's sport without beaters, loaders, shooting ponies and other expensive paraphernalia.

In 'A Repose after Shooting', their day draws to an end. The stouter of the two men reclines on the ground, one pointer curled up behind him, the other resting on the right; the second man stoops forward to display the day's bag, which includes a cock pheasant, snipe and another hare, all accurately portrayed in a minutely detailed still-life group.

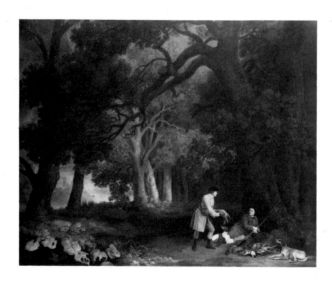

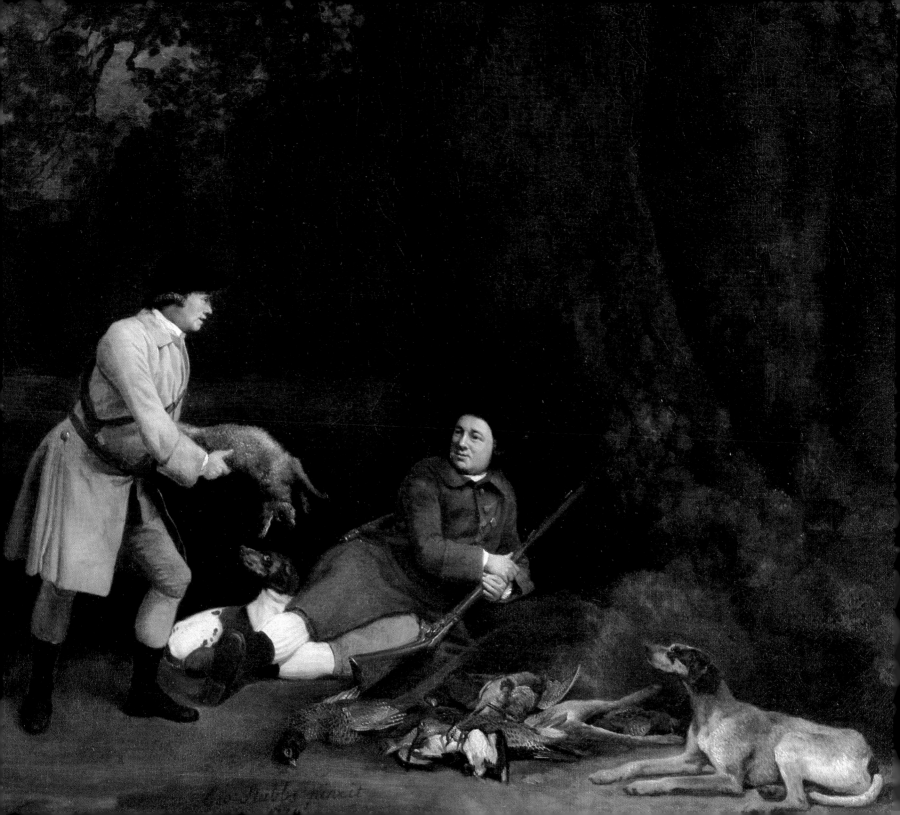

A REPOSE AFTER SHOOTING

DETAIL II

The day is fading; 'light thickens', in Shakespeare's phrase, and it is beginning to be difficult to discern one tree from another. Stubbs handles the darkening wood in a masterly manner; the trees still have individual identity, but the light which alone makes individual colour and shape distinct will not last much longer.

One of the great losses in our understanding of Stubbs's working methods is the apparent disappearance of all the sketches and studies which were in the sale of the contents of his studio after his death. 'One book of Trees' was among them. Stubbs's trees deserve close study; at their best, as here, they contribute powerfully to the mood of his picture.

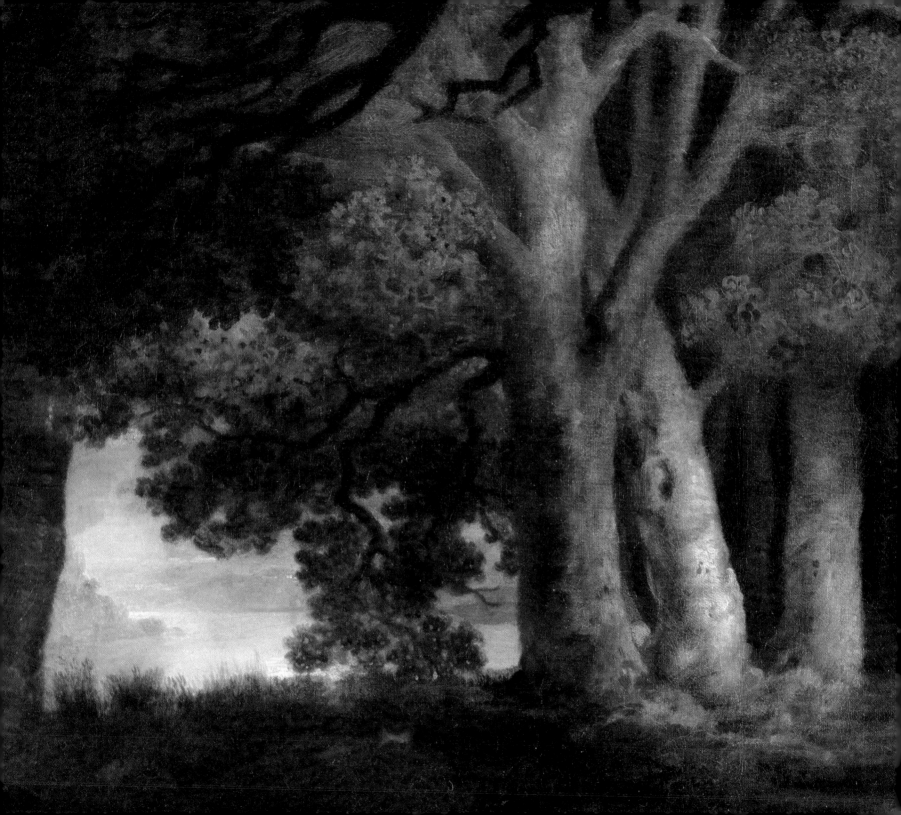

The Milbanke and Melbourne Families

circa 1770

Oil on canvas, $38\frac{1}{4} \times 58\frac{3}{4}$ in. (97.2 × 149.3 cm.)

Trustees of the National Gallery, London

The picture below commemorates the union of the two families by marriage. The sitters are, from left to right, Elizabeth Milbanke, later 1st Viscountess Melbourne, her father Sir Ralph Milbanke, 5th Bart., her brother John Milbanke and Peniston Lamb, later 1st Viscount Melbourne, whom Elizabeth Milbanke married on 13 April 1769. She was to prove by far the stronger character in that union, as Stubbs may have foreseen when he painted her driving herself into the picture in a tim-whisky, her hands firmly on the reins.

A tim-whisky, so-called because it is easy to imagine it whisking along, was a very light two-wheeled carriage drawn by a single horse or pony.

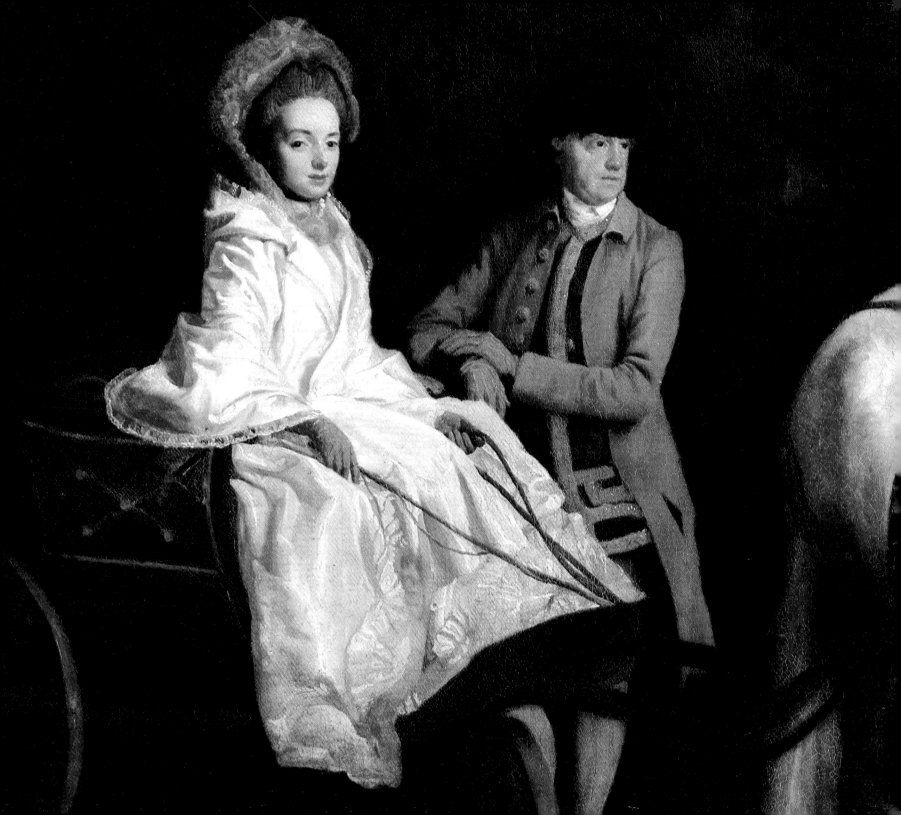

The Milbanke and Melbourne Families

Detail II

If John Milbanke's grey horse, in the centre of the composition, had been depicted at its full height and on the same plane as his sister's carriage-pony, the horse would have seemed to tower above the pony. Stubbs solves the problem by depicting the horse in an attitude in which its head and neck can be foreshortened, as it bends forward to crop the grass. We then have the illusion that the horse stands several feet behind the pony, although on the flat surface of the canvas there is only a finely judged hair's-breadth between them.

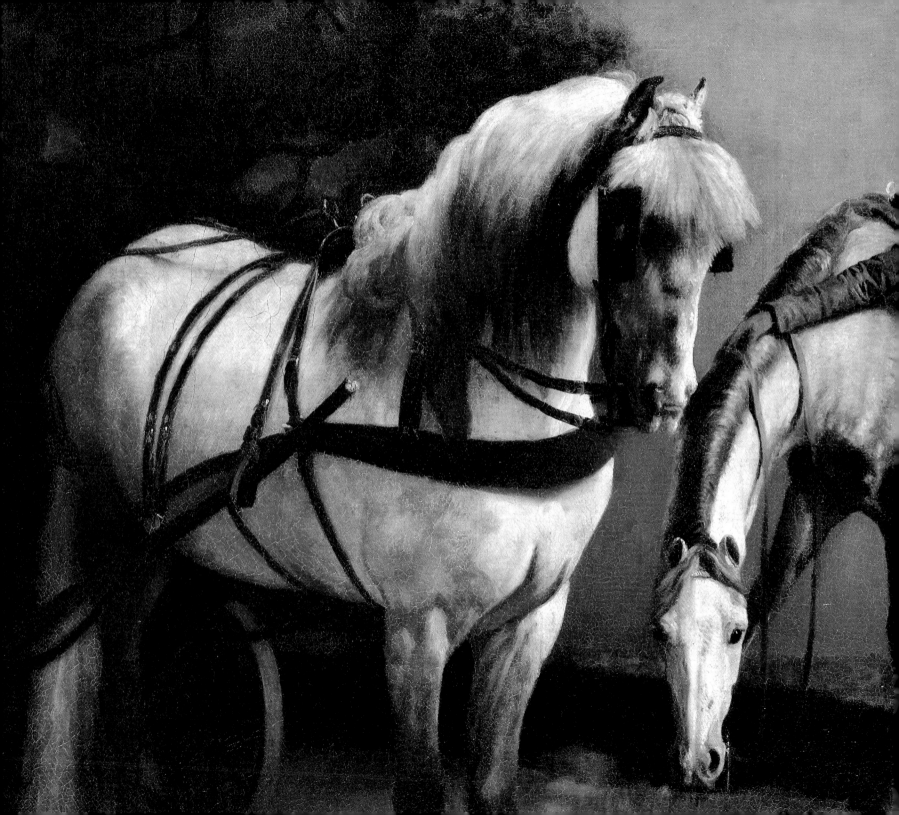

HAYMAKERS

dated 1785
Oil on panel, $35\frac{1}{4} \times 53\frac{3}{4}$ in. (89.5 × 135.2 cm.)
Tate Gallery

Stubbs's 'Haymakers' and 'Reapers' of 1785 were saved from export to America in 1977 with the aid of generous donations from public benefactors, private companies and countless members of the public. Their wide appeal is readily understandable, for they are the most lyrical of all representations of rural labour in England in the eighteenth century, as well as the most truthful.

 The figures and their poses were all drawn from life, then arranged into a design which is both graceful and realistic. The steady swing of the hayrakes as the women on the left gather in the outlying hay for the men to pitchfork on to the haycart seems to set the rhythm for the age-old team-work of the hayfield.

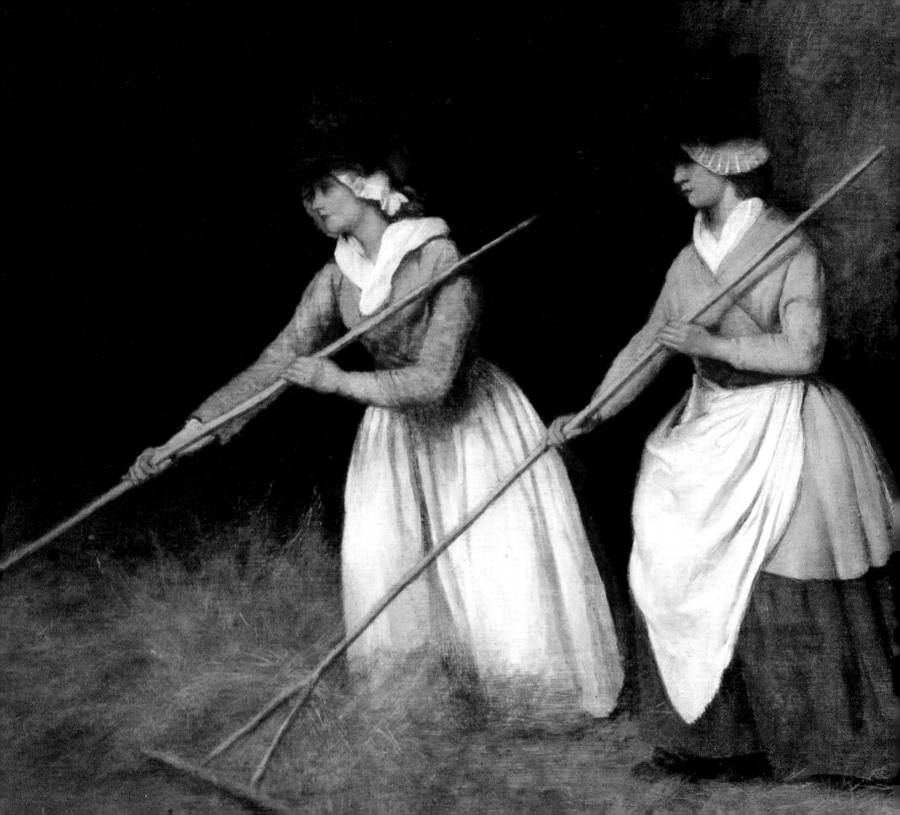

HAYMAKERS

DETAIL II

The design in 'Haymakers' is subtly pyramidal. The sloping angles of the women's hayrakes on the left lead the eye naturally upwards, while the shorter, stubbier lines of the men's pitchforks give solidity and compactness to the haycart's growing burden. The whole design is surmounted by the man on top of the cart, who holds his pitchfork vertically, in the centre of the composition, thus drawing all the lines in the picture upwards together.

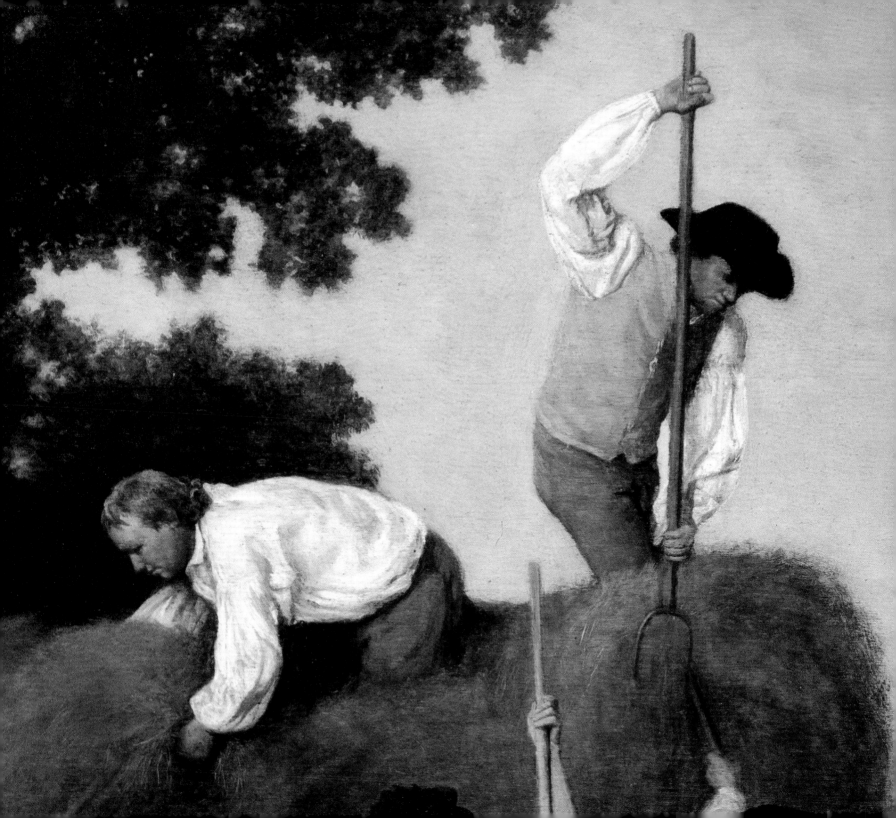

HAYMAKERS

DETAIL III

Stubbs then repeats the vertical line with the long handle of the rake held by the girl in the centre of the group: or, rather, he nearly repeats it, but not quite, for to have repeated it too exactly would have given too rigid a geometry to the design. Instead, with equal subtlety and truth, Stubbs paints the handle of her hayrake as slightly bowed, in the way home-made and well-worn implements so often are.

The girl pauses in her work, turning towards the spectator a steady but unprovocative gaze. Like the woman on the left, she wears elbow-length mittens, probably made of some impenetrable cloth, to protect her arms from being scratched by the dry hay; an unobtrusive detail, but a telling one, which plays its part in making Stubbs's figures realistic rather than merely charming.

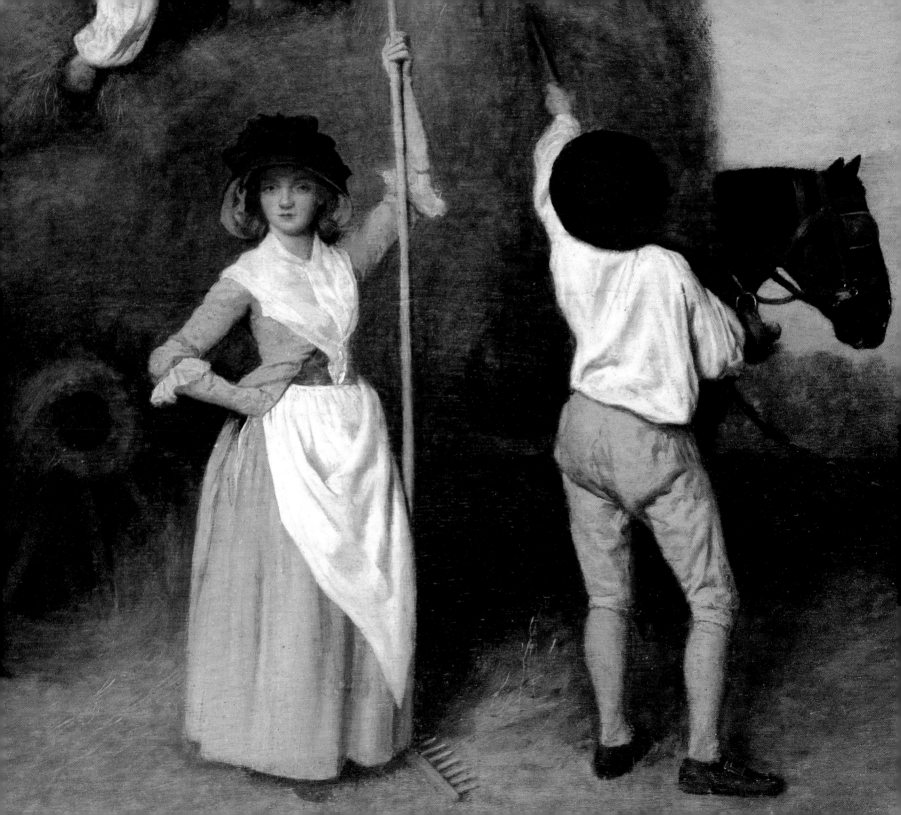

REAPERS

dated 1785
Oil on panel, $35\frac{1}{2} \times 53\frac{7}{8}$ in. (90 × 137 cm.)
Tate Gallery

In 'Reapers', the design follows a mainly horizontal line, as reapers themselves would in advancing along a cornfield; and the line gently undulates, like a cornfield in a breeze, through standing, stooping, bending, standing and again stooping figures until it is momentarily interrupted by a visitor riding in to see how the harvest progresses. Sketches and finished studies for 'Haymakers' and 'Reapers' were included in Stubbs's sale after his death, but are now lost. Stubbs habitually drew from life, painting only what he could see with his own eyes; we may suppose that the lost studies included exact observations of how men stooped over their sickles, how they stacked wheat or loaded a cart with hay. Even such commonplace details as the barrel and pitcher are painted with accuracy and affection combined.

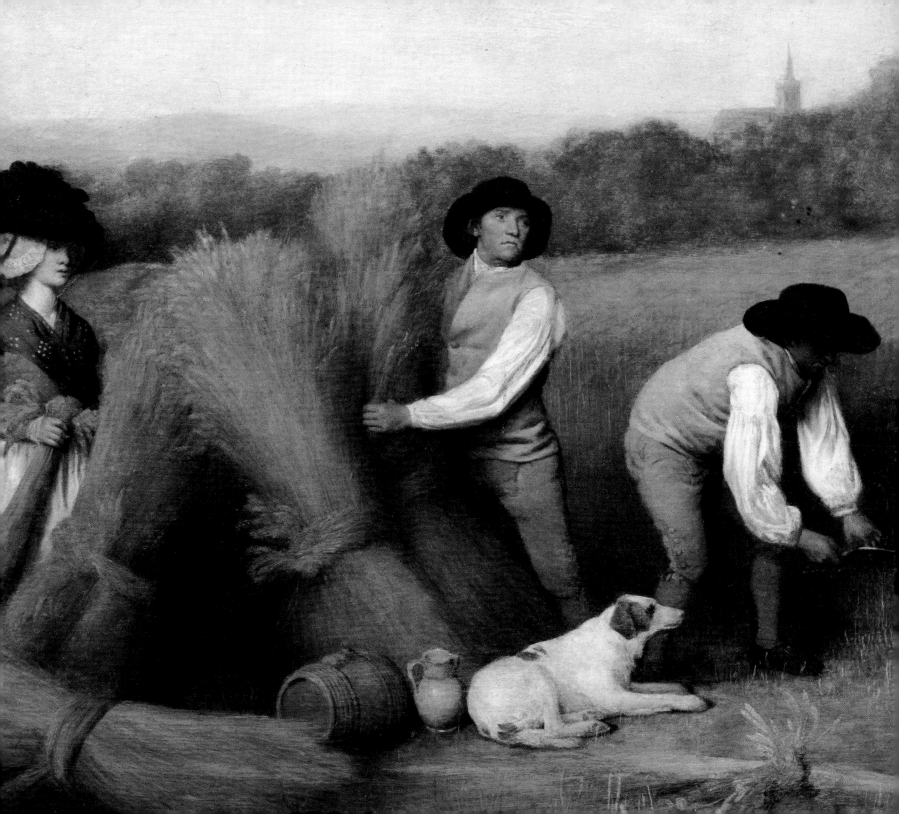

REAPERS

DETAIL II

As in 'Haymakers', a girl pauses in her work in the centre of the composition, perhaps to answer a question or return a greeting from the man – is he the landowner, or the farm manager? – who rides in to watch the harvest's progress. She too wears mittens, to protect her arms from dry, brittle cornstalks; her expression is modest, and quite unsentimental. It is hardly a romantic incident. Stubbs means us to see it, as he means us to see the whole picture, as a glimpse of everyday life whose gracefulness we may scarcely have realized until he shows it to us.

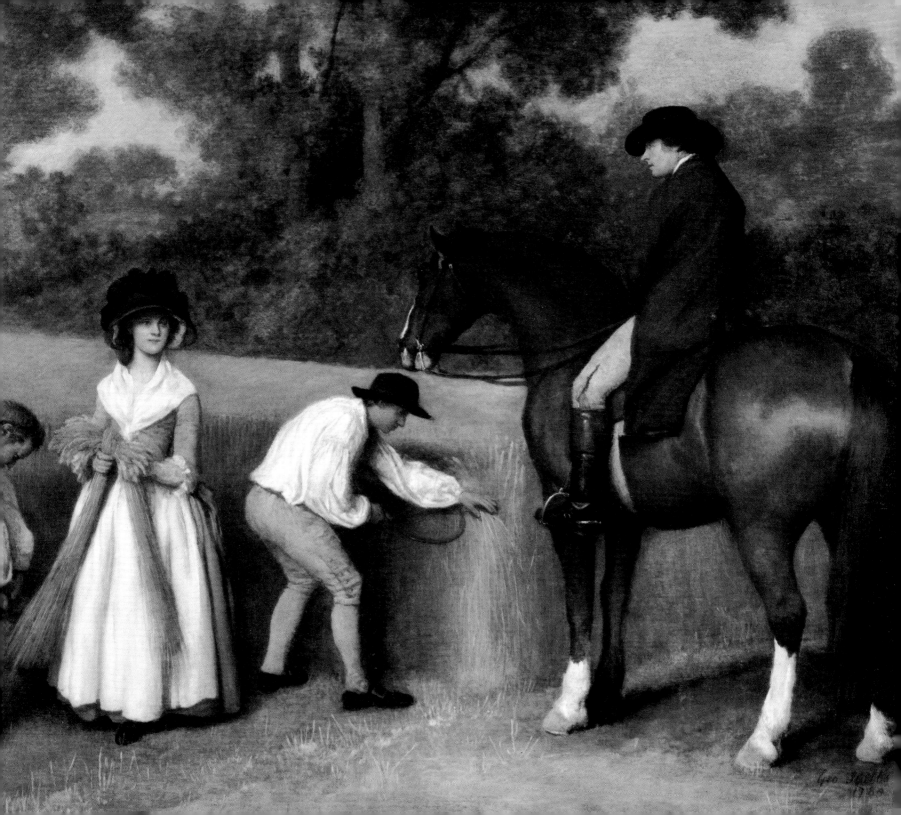

Hambletonian, Rubbing Down

dated 1800

Oil on canvas, $82\frac{1}{2} \times 144\frac{5}{8}$ in. (209×367.3 cm.)

National Trust, Mount Stewart

The impact of this painting upon the spectator is astonishingly powerful, and not just because it is life-size. It was commissioned by the young and arrogant Sir Henry Vane-Tempest to celebrate the victory of his racehorse Hambletonian in a match for 3,000 guineas against the Newmarket favourite Diamond. During that match, spectators noted that 'both horses were much cut with the whip, and severely goaded with the spur, but particularly Hambletonian: he was shockingly goaded'.

Into this picture, painted at the age of seventy-six, Stubbs seems to have poured a lifetime's knowledge of horses and those who look after them. Ignoring all conventions that racehorses should be portrayed as if immaculately groomed and in finest fettle, Stubbs portrays an exhausted animal which has passed through a formidable ordeal. The expression of the trainer who stands at the horse's head is ambiguous, or at least impassive: he knows that this horse needs quiet, and expert care, not gestures of affection or congratulation. It is after all his job to look after the horse so that he can race and win again – which Hambletonian was to do later that season.

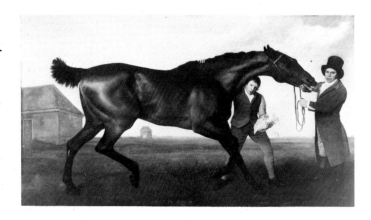

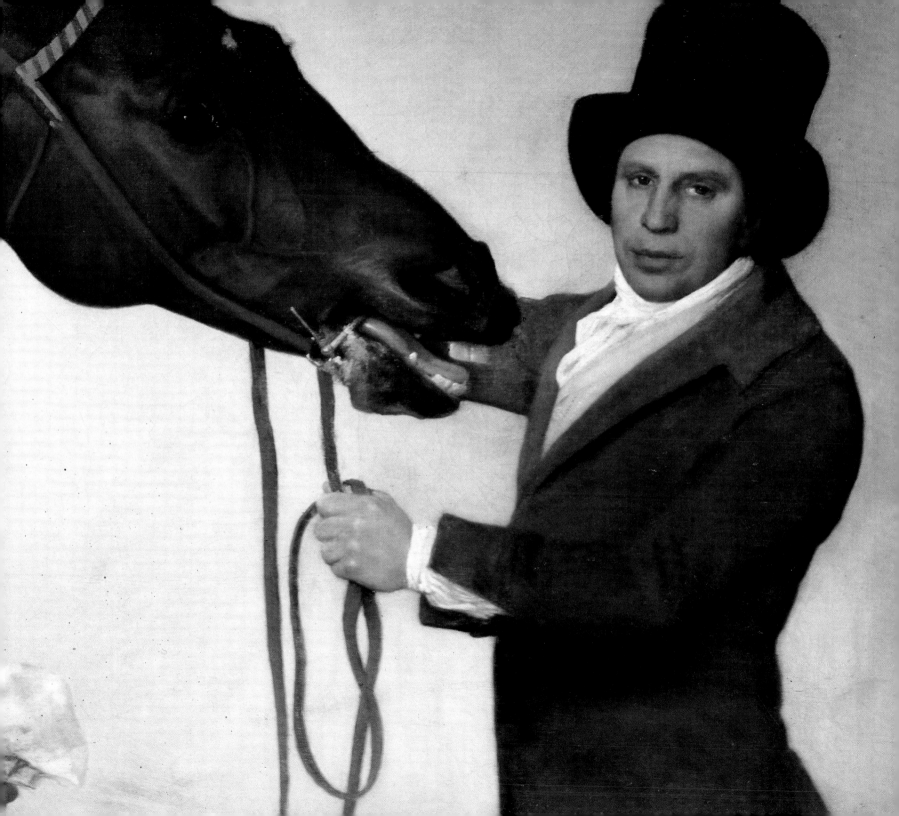

Hambletonian, Rubbing Down

DETAIL II

The stable-lad who rubs Hambletonian down is a mere boy, perhaps fifteen years old, with little experience yet written into his fresh, country features; he is there to obey the trainer's orders, and that, for the moment, is all he needs to know.

Sir Henry Vane-Tempest, who commissioned this picture, was dissatisfied with it; Stubbs had to take him to court to get his fee. 'Hambletonian, Rubbing Down' is a magnificent image; but it is hardly a cheerful one. Instead of an owner's triumph, Stubbs has painted a horse's ordeal; instead of featuring the owner's colours – lilac with yellow sleeves, and black cap – Stubbs deliberately plays down colour in favour of truth, and truth here is fustian stuff. Has a thinly striped dun-coloured waistcoat ever been more truthfully painted?

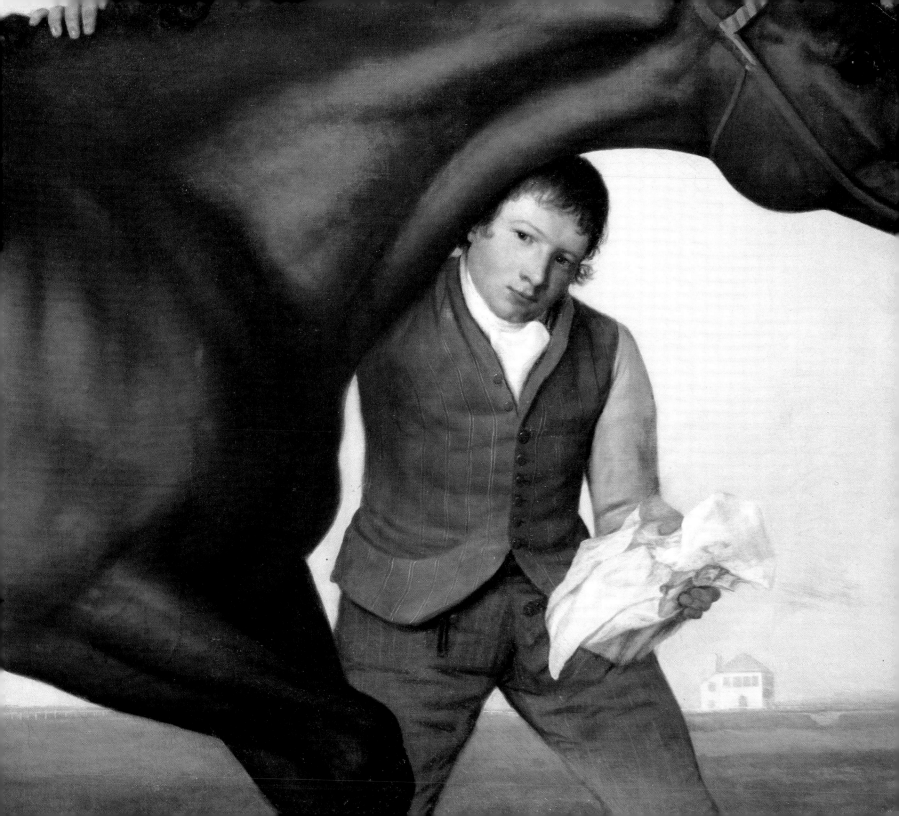